CW00749676

Kirsten Burke's

Secrets of Modern Calligraphy

PRACTICE PAD

LET'S GET LETTERING!

With this practice pad, you can try out three different types of guidelines, and get a few tips and tricks to help you to improve your calligraphy as you go.

How to Use This Book

*M*odern calligraphy is about lettering that has energy, without worrying too much about the traditional rules. While the lettering needs to look balanced on the page, it doesn't need to be perfect or identical every time.

*C*reating your own style and having fun is what it's all about. You have to concentrate to draw and balance your letterforms. It will also enable you to forget about everything else around you, so all your worries disappear.

*I*f you'd like more guided projects with expert tips and tricks to help you on your lettering journey, why not pick up a copy of my book **Secrets of Modern Calligraphy** available from most high-street and online retailers. In it, I share more of my secrets and shortcuts to help make learning calligraphy a little easier and a lot more fun!

IT'S ALL ABOUT PRACTICE!

Grab a little 'Me' time all to yourself to practise your strokes. With calligraphy you can take your nib away from the page as often as you need to and ponder your next stroke.
Don't worry if your upstrokes are a little wobbly at first — be patient. The more you practise, the more natural it becomes.

Watch

Access **Kirsten Burke Calligraphy** video tutorials on our YouTube channel to see practical tips and advice to help you to develop your skills and confidence. Whenever you see the symbol above, scan the QR code with your phone or tablet to see demonstrations and how-to videos. You'll need a QR code reader app, which is free to download.

Ink and Nibs

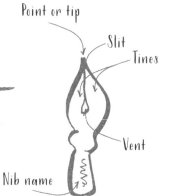

Push the nib in against the inside edge of the penholder.

What inks should I use:

There are many different inks on the market and they are either coloured with pigments or dyes. Dyes are thinner so more likely to bleed, so we'd recommend using pigment inks on this practice pad. If your ink is bleeding, add a small amount of 'Gum Arabic' to it so that it is thick enough not to bleed, but thin enough to write with.

Pointed Nibs

Your pointed nib is made up of two split pieces of metal that fit perfectly together. These are called the 'tines'. The tines lead to a small hole called a 'vent', which holds the ink.

The tines must open up as you write to allow the ink or paint to flow out. Before you even dip your nib into the ink, if you place the tip of your nib flat on the paper and apply some pressure, you will see them open up. The more they open up, the thicker your stroke will be.

There are so many different pointed nibs available that choosing the right one can be confusing. In my experience, most beginners are worried about pushing down on their nibs in case they break and so don't use enough pressure.

My 'Essential Modern Calligraphy Kit' is an easy way to get started. It contains a penholder, my three favourite nibs, black ink and a tin to keep it all safe in.

My Choice of Nibs

Leonardt 30 - the most popular by far in my workshops. Great ink flow, and flexible enough to make those thick and thin lines easily.
Principal EF (Extra Fine) - great for smaller calligraphy, it gives beautiful fine lines.
Leonardt 256 - a firmer nib for those who use more pressure when they write.

Seasoning

Nibs have a glaze on them. It not only protects from rusting, but also repels the ink, so you need to remove it. Just hold the nib over a flame for a few seconds, as if you were sterilising a needle. This is called 'seasoning'.

Fitting the Nib

Push the nib firmly into the side of the four 'petals', against the inside rim of the penholder. Push the nib in as far as it will go, so that it feels totally secure.

YouTube
Kirsten Burke Calligraphy
Secrets-Nibs

Getting Started

Types of Penholder
Straight - great for beginners and experts alike.
Oblique - the one with the strange angled head in the illustration below.

Paper Position
If you use a straight penholder, turn your paper 40 degrees anticlockwise (clockwise for lefties).

If you choose to work with an oblique penholder, you can have your paper positioned straight in front of you (see below).

The pointed nib used with an oblique penholder was designed for 'copperplate' calligraphy, a beautiful antique writing style with a flourish.

Downstrokes
Pulling your pen down the page forces the tines to spread open, giving you a thick stroke. The more pressure you apply, the thicker the stroke. But be careful – too much pressure may snap the nib.

Upstrokes
Pushing the pen up the page is a bit trickier. The nib can easily catch on the fibres in the paper, so go lightly! You need to apply as little pressure as possible without losing ink flow.

Cross-strokes
Your cross-strokes are the horizontal lines on an 'f' or a 't', for example. A gentle touch is needed as the nib will separate very slightly, giving you a thin line. It should be a little thicker than an upstroke.

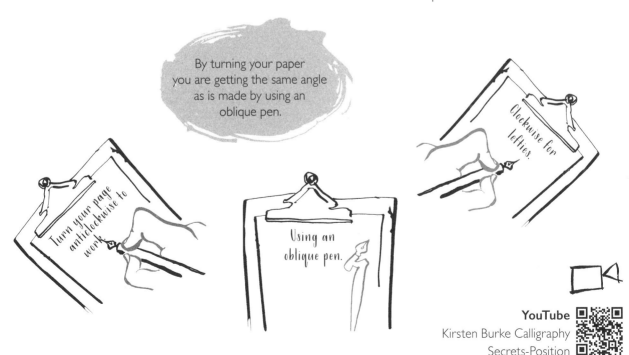

By turning your paper you are getting the same angle as is made by using an oblique pen.

Turn your page anticlockwise to work.

Using an oblique pen.

Clockwise for lefties.

YouTube
Kirsten Burke Calligraphy
Secrets-Position

Using the Guides

In traditional calligraphy, every letter would sit neatly on the baseline and each letter would follow a strict set of rules. Modern calligraphy gives letters a chance to play with the rules, 'show off' and dance around the guidelines.

Different guides allow you to work in different ways, so I have included three alternatives for you to experiment with: lined guides to help with proportion; angled guides to help you to set the angle of your lettering; then dotted guides that give you a much more flexible framework to allow you to knit your letters together and play around with them.

Ascenders are the upward 'branches' of the letters. They reach almost to this top line. Capital letters reach this line, too.

Ascenders and Capitals
Waistline
X height
Baseline
Descenders

Fun & Playful

The X height is the height of the body of your lower-case letters. In traditional calligraphy all the letters would be exactly this height, in modern calligraphy the letters dance around within this space.

Descenders are the downward tails of the lower-case letters.

Ascenders and Capitals
Waistline
X height
Baseline
Descenders

Modern & Bouncy

Can you see the way the thick downstrokes are all at the same angle as depicted by the diagonal blue lines? A consistent angle or tilt is what you are aiming for.

In modern calligraphy your letters can dance around the base- and waistline. However, if your angle keeps changing, it can make your work look messy, so pick an angle and stick with it throughout a project!

Ascenders and Capitals
Waistline
Baseline
Descenders

Knitted Lettering

The first word is sitting on the baseline that I have overlaid onto this dotted grid. The word below is able to move much nearer and 'tuck' into the letter shape above because the dotted guides are not so rigid.

Brilliant
Birthday
Let's Dance
I love you
Just to say
Valentine

just to say

Congratulations

Happy Holiday

Home Sweet Home

& you're Invited

Hooray for Cake

Let's Celebrate

Alphabets

Remember to breathe!
Allow your forearm to glide over the desk
rather than leaning on it.
Enjoy copying the following alphabets,
playing with the flow of the letters and getting your
thick and thin strokes in the right place.

Quirky Upright

abcdefghi
jklmnopq
rstuvwxyz

1234567890

A B C D E F G

H I J K L M N

O P Q R S T

U V W X Y Z

Tip

When you connect letters to make words, notice
that your joining stroke is always a thin, upward one.
Don't be tempted to flick your pen on the upstroke.
Calligraphy is about control, so even the thin lines need
to be careful and deliberate for a crisp look.

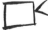

YouTube
Kirsten Burke Calligraphy
Secrets-Thick and Thins

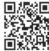

Flourished Alphabet

a b c d e f g h i j k

l m n o p q

r s t u v w x y z

1 2 3 4 5 6 7 8 9 0

A B C D E F G

H I J K L M N

O P Q R S T U

V W X Y Z

ee

Tip
Play around with the rules for a modern twist, but
always keep your eye on the lettering and phrasing.
You want your work to be legible.

Italic Modern

a b c d e f g
h i j k l m n o
p q r or r s t u
v w x y z

1 2 3 4 5 6 7 8 9 0

A B C D E F G

H I J K L M

N O P Q R S T

U V W X Y Z

Z

Tip
When you feel the ink running out, try to get to the end of a stroke then dip.
That way your strokes will flow. If the ink stops before you get to the end,
dip and do your best to join where you stopped as smoothly as you can.

Lined Guides

The horizontal guide lines are there to keep your lettering straight, but with modern calligraphy your letters can bounce up and down along them.

Ascenders and Capitals

Waistline

X height

Baseline

Descenders

Fun & Playful

A
W
B
D

Aa

Bb

Cc

Dd

Ee

Ff

Gg

Hh

Ii

Practice Makes Perfect

A
W
B
D

Jj

Kk

Ll

Mm

Nn

Oo

Pp

Qq

Tip
Not sure you're holding the pen correctly?
The vent should be facing straight upwards. If your nib is turned to the right
or left, the tines won't open so the ink can't flow out of the nib.

Practice Makes Perfect

AWBD

Rr

Ss

Tt

Uu

Vv

Ww

Xx

Yy

Zz

Practice Makes Perfect

A

W

B

D

Practice Makes Perfect

A
W
B
D

Practice Makes Perfect

 Tip
Does your pen feel scratchy, particularly on the upstrokes?
Lighten your grip on the pen. Or you could be holding the pen too
upright. Drop the penholder to a 30-degree angle from the page.

Practice Makes Perfect

Practice Makes Perfect

Tip
If the ink won't come out of the pen, give the nib a little wiggle on the spot that you're on and it will flow.

Practice Makes Perfect

Practice Makes Perfect

Practice Makes Perfect

"My letters have the thick stroke at the bottom not the side!"
This is a very common complaint at the beginning. Check the angle of your
paper and move it slightly. Try writing again and see if it's improved.

Practice Makes Perfect

Practice Makes Perfect

Practice Makes Perfect

Practice Makes Perfect

Practice Makes Perfect

Practice Makes Perfect

Tip

If your downstrokes are not coming out thick enough, you may have twisted the pen so the tines can't open. Think of the pen as two skis coming down a slope. They need to stay flat and parallel as they glide over the snow. It's the same with the tines.

Practice Makes Perfect

Practice Makes Perfect

Practice Makes Perfect

Practice Makes Perfect

Practice Makes Perfect

Practice Makes Perfect

Practice Makes Perfect

Practice Makes Perfect

Angle Guides

Perfect for writing italic calligraphy.
Keeping the angle of your letters
consistent is difficult when you first start,
so these guides are a great help.

YouTube
Kirsten Burke Calligraphy
Secrets-Angles

X height

Modern & Bouncy

A
W
B
D

Aa

Bb

Cc

Dd

Ee

Ff

Gg

Hh

Practice Makes Perfect

A
W
B
D

Ii

Jj

Kk

Ll

Mm

Nn

Oo

Pp

Qq

Practice Makes Perfect

Rr

Ss

Tt

Uu

Vv

Ww

Xx

Yy

Zz

Practice Makes Perfect

Practice Makes Perfect

Practice Makes Perfect

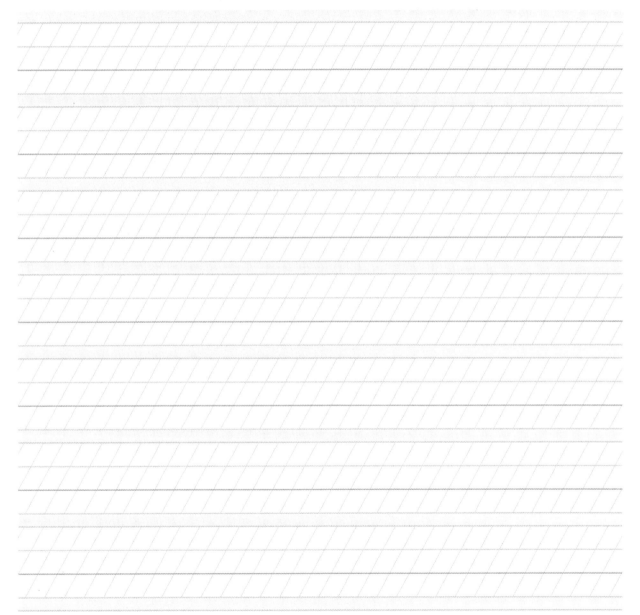

Practice Makes Perfect

Tip

Try making a downstroke without dipping in the ink
so that you can check the tines are opening up.

Practice Makes Perfect

Practice Makes Perfect

Practice Makes Perfect

Practice Makes Perfect

If you're picking up fibres on your nib, you are possibly pushing too hard. It can also happen when you go back over a stroke that is still wet. Wipe the nib to pull the fibres off and carry on with a lighter touch.

Practice Makes Perfect

Practice Makes Perfect

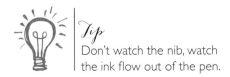

Tip
Don't watch the nib, watch
the ink flow out of the pen.

— 55 —

Practice Makes Perfect

Practice Makes Perfect

Practice Makes Perfect

Practice Makes Perfect

Practice Makes Perfect

Practice Makes Perfect

Practice Makes Perfect

Practice Makes Perfect

Practice Makes Perfect

Practice Makes Perfect

Practice Makes Perfect

Practice Makes Perfect

Dotted Guides

A fantastic flexible guide.
Use the horizontal dots to keep
your letters even and straight. You can also
use this grid to create 'knitted' compositions.
Tuck your calligraphy close together as you write
each new line, so that you fill the spaces made
by the words above.

Ascenders and Capitals

Waistline

Baseline

Descenders

Knitted Lettering

Practice Makes Perfect

Practice Makes Perfect

Practice Makes Perfect

Practice Makes Perfect

Are you holding your breath?
We often do when we are
concentrating! Try to remember to
relax, take deep breaths and keep your
shoulders loose. This is supposed
to be fun!

Practice Makes Perfect

Practice Makes Perfect

Practice Makes Perfect

Practice Makes Perfect

While the curves and curls of your calligraphy change direction, the angle you hold your pen remains the same.

Practice Makes Perfect

Practice Makes Perfect

Practice Makes Perfect

Practice Makes Perfect

Tip

Try to relax your arm and keep a steady rhythm as
it helps with consistency.

Practice Makes Perfect

Practice Makes Perfect

Practice Makes Perfect

Practice Makes Perfect

Practice Makes Perfect

Practice Makes Perfect

Practice Makes Perfect

Practice Makes Perfect

Practice Makes Perfect

Practice Makes Perfect

Practice Makes Perfect

Practice Makes Perfect

Our Story

I can hardly believe I've been a professional calligrapher for more than twenty years! After completing my degree in graphic design in 1992, I did a postgraduate course in traditional calligraphy, illuminated lettering, gilding and bookbinding.

I learnt to use a broad edged nib to create the most exquisitely perfect lettering, with every letter and angle identical. But what I loved most was making bold, abstract, vibrant artworks. I'd take the meaning of a piece and translate it into art – making pictures out of the words. Back in those days, nobody knew what a calligrapher was. At dinner parties, I'd get blank stares and people saying, 'so do you make a living writing names on certificates like the monks did?' Luckily for me, times have changed, and people now want to have a go at creating calligraphy fonts for themselves.

My contemporary lettering style developed from a combination of my traditional training with a nib, and the ancient brush lettering practised in the Far East. This is free-flowing, with lots of energy and movement. I created huge designs with lots of 'dipped' colour changes using an automatic pen (which is a bit like a giant broad edged nib) so that I could get the bold, energetic lines that I loved.

I played with the rules and broke them, pushing the boundaries of what was accepted. I learnt to use a ruling pen – which is often used in technical drawing – so that I could work super fast, adding splats and splashes, giving my work a more 'random' dimension. I used 'resist' to work in negative space, writing with a clear medium on a coloured or black background. I would take a blank sheet of paper, add an

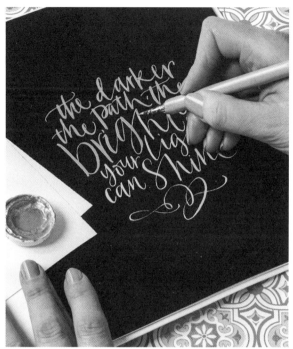

invisible layer of words, then paint over them with a huge paintbrush to reveal an often illegible pattern of words that would have to be puzzled out. My big break came in 1997 when I was commissioned to create a 13 metre-long timeline for the iconic Globe Theatre, Bankside, depicting Shakespeare's life and work. I set up Kirsten Burke Calligraphy from a studio in Deptford with a school friend, Jill.

*O*ver the past twenty years we have exhibited many styles of artwork in galleries nationwide. Through private, corporate and public art commissions, my style of modern calligraphy has been applied to many different surface types. This has livened up both interior and exterior spaces with canvas, wooden panels and even designs on glass. We have worked for hundreds of clients, on chocolate body butter for BHS to

recreating Guy Fawkes' confession for the BBC. We now have a large and dedicated team of calligraphers who share our passion for modern calligraphy, working with us on national campaigns for luxury clients. With Jill taking care of the business, I am able to indulge in my love of lettering, experiment with new ideas and share my passion and experience through the workshops that I run for people of all ages and abilities from our beautiful studio in leafy West Sussex, near the beach. Our workshops now run nationwide, with a team of trained and experienced calligraphers.

I am so grateful that I've been given the chance to reach out to new people all over the world through books, including this practice pad, and through platforms such as Youtube and social media. Long may this continue!

Congratulations!
You have filled your whole practice pad with beautiful calligraphy. There may be a splodge or a wobble here and there, but that's all part of the journey. You are improving every time you put pen to paper, so keep going, and have fun creating calligraphy.

A STUDIO PRESS BOOKS

First published in the UK in 2018 by Studio Press,
an imprint of Bonnier Books UK,
The Plaza, 535 King's Road, London, SW10 0SZ
Owned by Bonnier Books, Sveavägen 56, Stockholm, Sweden

www.studiopressbooks.co.uk www.bonnierbooks.co.uk

Copyright © 2018 Kirsten Burke

3 5 7 9 10 8 6 4 2

All rights reserved
ISBN 978-1-78741-374-0

By Kirsten Burke and Jill Hembling

Printed in China

YouTube: Kirsten Burke The Modern Calligraphy Co
Instagram: themoderncalligraphyco
Twitter: kirstenburkeart
Facebook: The Modern Calligraphy Co.
Pinterest: The Modern Calligraphy Co.
www.themoderncalligraphyco.com

All product and company names, images, brands and trademarks are the property of their respective owners, which are in no way associated or affiliated with Studio Press, or Jill Hembling and Kirsten Burke. Product and company names, websites and images are used solely for the purpose of identifying the specific products that are used. Use of these names and images does not imply any responsibility, cooperation or endorsement.

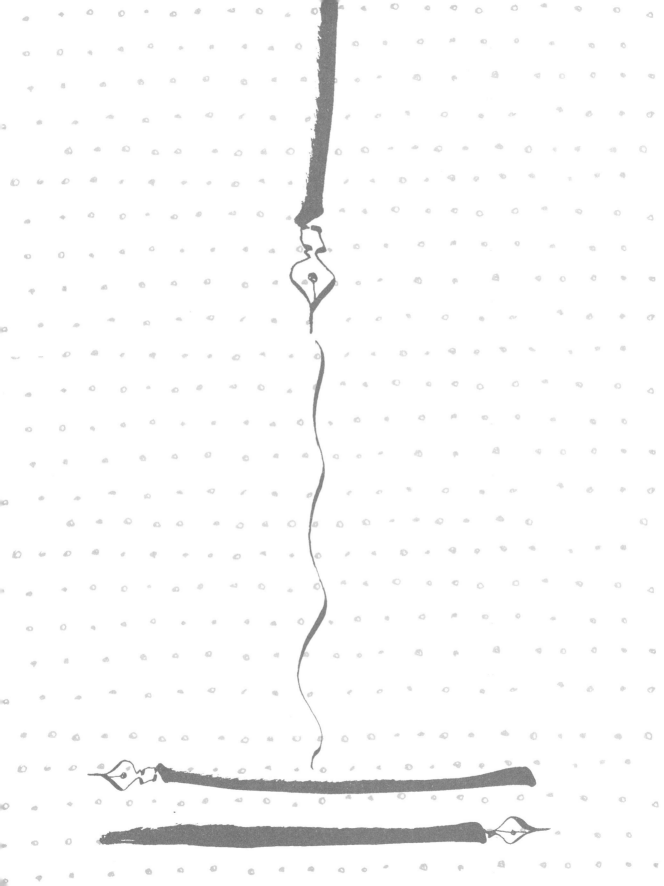